DOVER MASTERWORKS

Color Your Own

FAMOUS AMERICAN

Paintings

Rendered by

Marty Noble

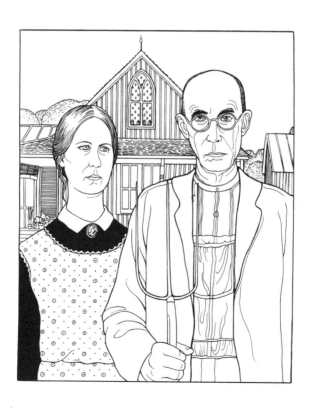

Dover Publications, Inc.
Mineola, New York

Note

In this interesting coloring collection, you'll find thirty detailed renderings of famous American paintings. Encompassing two centuries of impressive achievement, this book presents a variety of styles and themes by artists such as Gilbert Stuart and John Singleton Copley; Hudson River School landscape painters Thomas Cole and Asher B. Durand; American Impressionists Mary Cassatt and Childe Hassam; as well as artists who embraced more modern techniques, including George Bellows, Thomas Hart Benton, and Grant Wood.

All thirty paintings are arranged alphabetically by the artist's last name, and are shown in full color on the inside covers for easy reference. Choose your media, and then follow the artist's color scheme for an accurate representation of the original work, or pick your own colors for a more personal touch. When you're finished coloring, the perforated pages make it easy to display your finished work. Captions on the reverse side of each plate identify the artist and title of the work, date of composition, medium employed, the size of the original painting, and include interesting biographical facts about the artist.

Copyright

Copyright © 2005, 2013 by Dover Publications, Inc.
All rights reserved.

Bibliographical Note

Dover Masterworks: Color Your Own Famous American Paintings, first published by Dover Publications, Inc., in 2013, is a slightly altered republication of *Color Your Own Famous American Paintings*, first published by Dover in 2005.

International Standard Book Number

ISBN-13: 978-0-486-77942-3
ISBN-10: 0-486-77942-4

Manufactured in the United States by Courier Corporation
77942402 2014
www.doverpublications.com

Guide to the Famous American Paintings

GEORGE WESLEY BELLOWS. *Dempsey and Firpo*, 1924. Oil on canvas. 51 x 63¼ in. Plate 1

THOMAS HART BENTON. *Self-Portrait with Rita*, 1922. Oil on canvas. 49½ x 40 in. Plate 2

ALBERT BIERSTADT. *Emigrants Crossing the Plains*, 1867. Oil on canvas. 67 x 102 in. Plate 3

GEORGE CALEB BINGHAM. *Fur Traders Descending the Missouri*, 1845.
Oil on canvas. 29 x 37 in. Plate 4

MARY CASSATT. *Mother and Child*, 1905. Oil on canvas. 36¼ x 29 in. Plate 5

WILLIAM MERRITT CHASE. *Portrait of Miss Dora Wheeler*, 1883.
Oil on canvas. 62½ x 65¼ in. Plate 6

FREDERIC CHURCH. *Cotopaxi*, 1862. Oil on canvas. 48 x 85 in. Plate 7

THOMAS COLE. *Genesee Scenery (Mountain Landscape with Waterfall)*, 1847.
Oil on canvas. 51½ x 39¼ in. Plate 8

JOHN SINGLETON COPLEY. *Watson and the Shark*, 1778. Oil on canvas. 71¾ x 90½ in. Plate 9

ASHER B. DURAND. *Kindred Spirits*, 1849. Oil on canvas. 46 x 36⅛ in. Plate 10

THOMAS EAKINS. *The Biglin Brothers Racing*, 1873. Oil on canvas. 24 x 36 in. Plate 11

WILLIAM GLACKENS. *Chez Mouquin*, 1905. Oil on canvas. 48 x 39 in. Plate 12

CHILDE HASSAM. *Allies Day, May 1917*, 1917. Oil on canvas. 36¾ x 30¼ in. Plate 13

EDWARD HICKS. *The Peaceable Kingdom*, ca. 1837. Oil on canvas. 29 x 36 in. Plate 14

WINSLOW HOMER. *Snap the Whip*, 1872. Oil on canvas. 22¼ x 36½ in. Plate 15

EDWARD HOPPER. *Hotel Room*, 1931. Oil on canvas. 60 x 65 in. Plate 16

GEORGE INNESS. *The Lackawanna Valley*, 1855. Oil on canvas. 34 x 50 in. Plate 17

JONATHAN EASTMAN JOHNSON. *The Old Stagecoach*, 1871.
Oil on canvas. 36¼ x 60⅛ in. Plate 18

EMANUEL LEUTZE. *Washington Crossing the Delaware*, 1851.
Oil on canvas. 149 in. x 255 in. Plate 19

ALFRED MILLER. *Setting Traps for Beaver*, 1837. Watercolor. 7⅞ in. x 10¼ in. Plate 20

GRANDMA MOSES. *Early Springtime on the Farm*, 1945. Oil on canvas. 16 x 25¾ in. Plate 21

CHARLES WILLSON PEALE. *The Artist in His Museum*, 1822.
Oil on canvas. 103¾ x 79⅞ in. Plate 22

MAURICE PRENDERGAST. *Central Park*, c. 1908–10. Oil on canvas. 20¾ x 27 in. Plate 23

FREDERIC REMINGTON. *A Dash for the Timber*, 1889. Oil on canvas. 48½ x 84⅛ in. Plate 24

JOHN SINGER SARGENT. *Paul Helleu Sketching with His Wife*, 1889.
Oil on canvas. 26⅛ x 32⅛ in. Plate 25

GILBERT STUART. *George Washington*, 1795. Oil on canvas. 29¼ x 24 in. Plate 26

BENJAMIN WEST. *Colonel Guy Johnson*, 1775. Oil on canvas. 79¾ x 54½ in. Plate 27

JAMES MCNEILL WHISTLER. *Portrait of the Artist's Mother*, 1871.
Oil on canvas. 56¾ x 64 in. Plate 28

GRANT WOOD. *American Gothic*, 1930. Oil on beaverboard, 29 x 24½ in. Plate 29

N. C. WYETH. *Nothing Would Escape*, 1911. Oil on canvas. 46½ x 37½ in. Plate 30

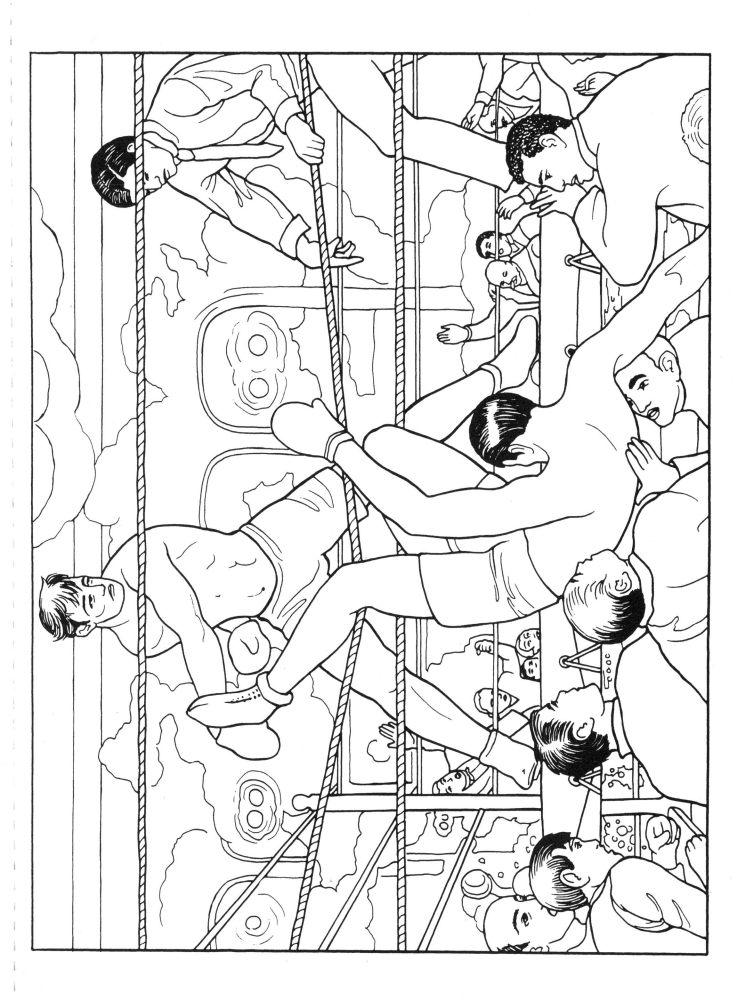

Plate 1
George Wesley Bellows. *Dempsey and Firpo*, 1924.
Oil on canvas. 51 x 63¼ in.

Born in Columbus Ohio in 1882, George Wesley Bellows was an American realist painter who achieved notoriety for his vivid depictions of urban life in turn-of-the-century New York City. His themes often focused on the daily lives of the working-class, though he was also known for his satirical paintings that poked fun at the upper class. Bellows worked on *Dempsey and Firpo* for several months in 1923 and 1924. The painting depicts the famous 1923 fight in which U.S. heavyweight champion Jack Dempsey beat South American heavyweight champion Luis Angel Firpo, in a match that has been called the most savage two rounds in boxing history.

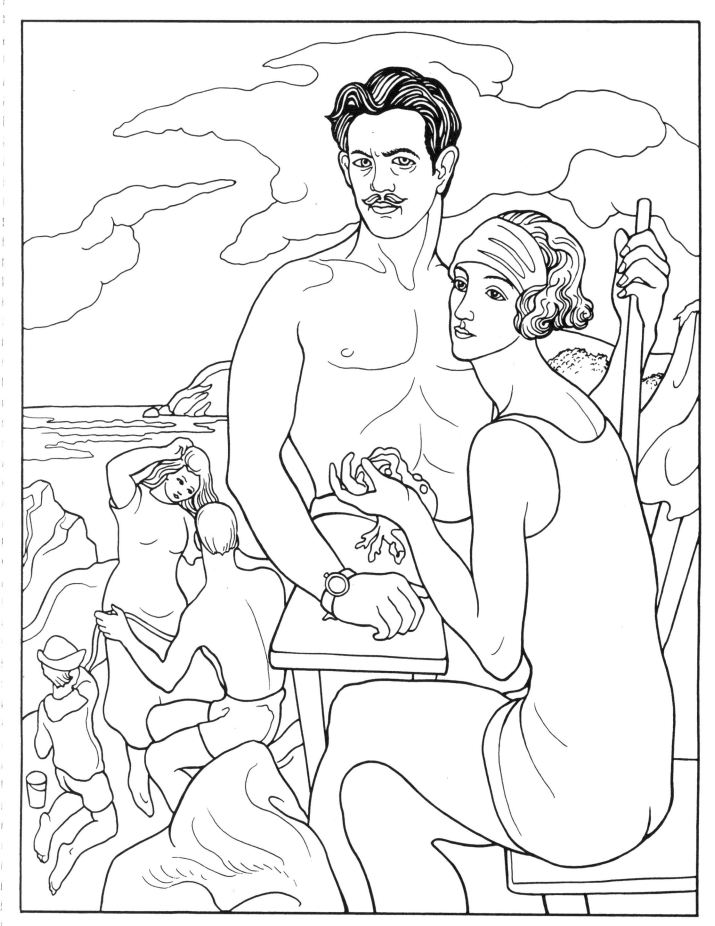

Plate 2
Thomas Hart Benton. *Self-Portrait with Rita*, 1922.
Oil on canvas. 49½ x 40 in.

Thomas Hart Benton was an American painter in the Regionalist movement, known for his depictions of everyday life in middle America. Having declared himself an "enemy of modernism" in the early 1920s, Benton strove for a naturalistic style and is particularly remembered for his depictions of American life in the post-depression era. This painting depicts the artist and his wife Rita, sunbathing in Martha's Vineyard.

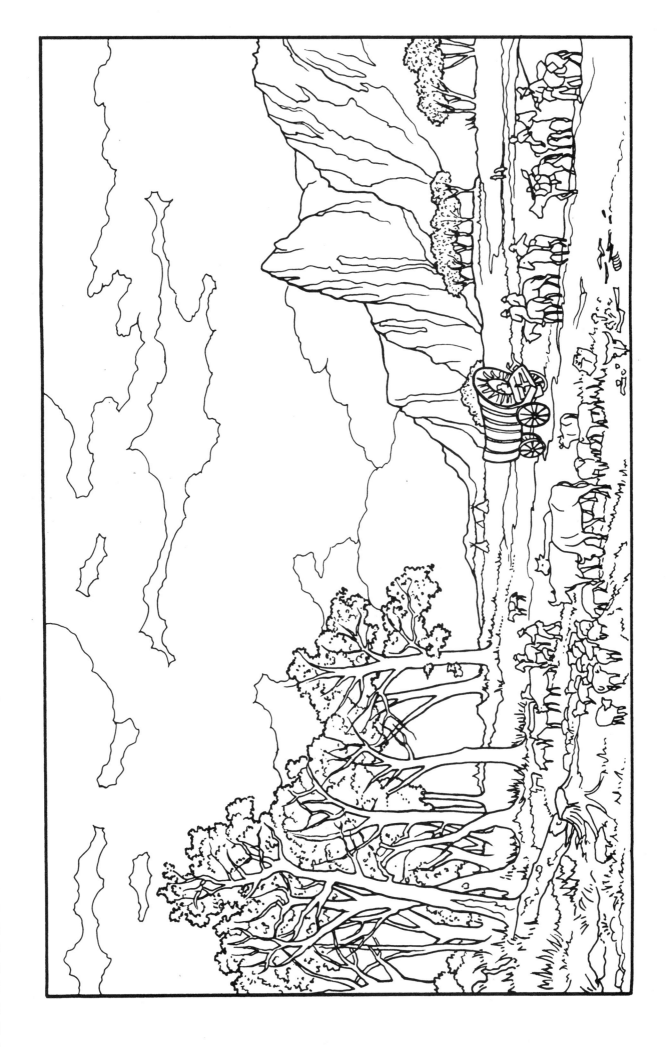

Plate 3
Albert Bierstadt. *Emigrants Crossing the Plains*, 1867.
Oil on canvas. 67 x 102 in.

Born in Solingen, Germany in 1830, Albert Bierstadt emigrated to the United States as a young child, settling with his family in New Bedford, Massachusetts. Though he began his work painting in New England and New York, he is best known for his large, romantic landscapes of the American West. In this painting, Bierstadt depicts a group of settlers making the overland journey from the East to Oregon.

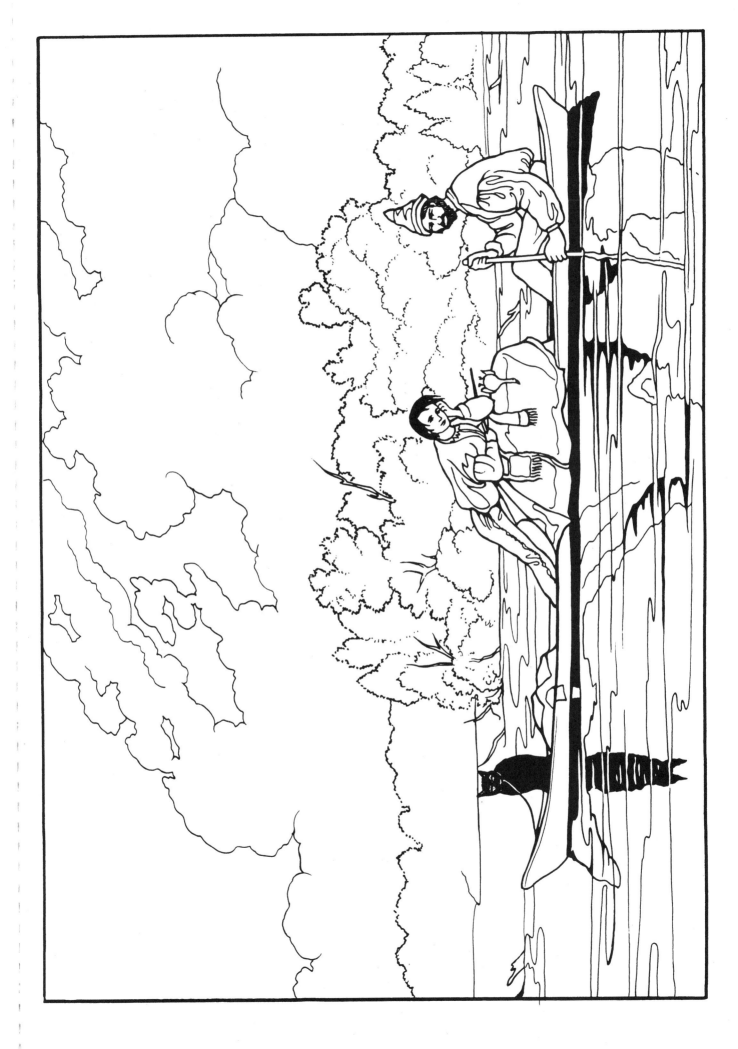

Plate 4
George Caleb Bingham. *Fur Traders*
Descending the Missouri, **1845.**
Oil on canvas. 29 x 37 in.

George Caleb Bingham was an American painter known for his beautiful, tranquil depictions of the American West. One of the best examples of Luminist style painters, Bingham primarily chose scenes from daily life on the Missouri frontier. Perhaps his most famous work, *Fur Traders Descending the Missouri* depicts a French trader rowing on the Missouri river with his half-Native American son.

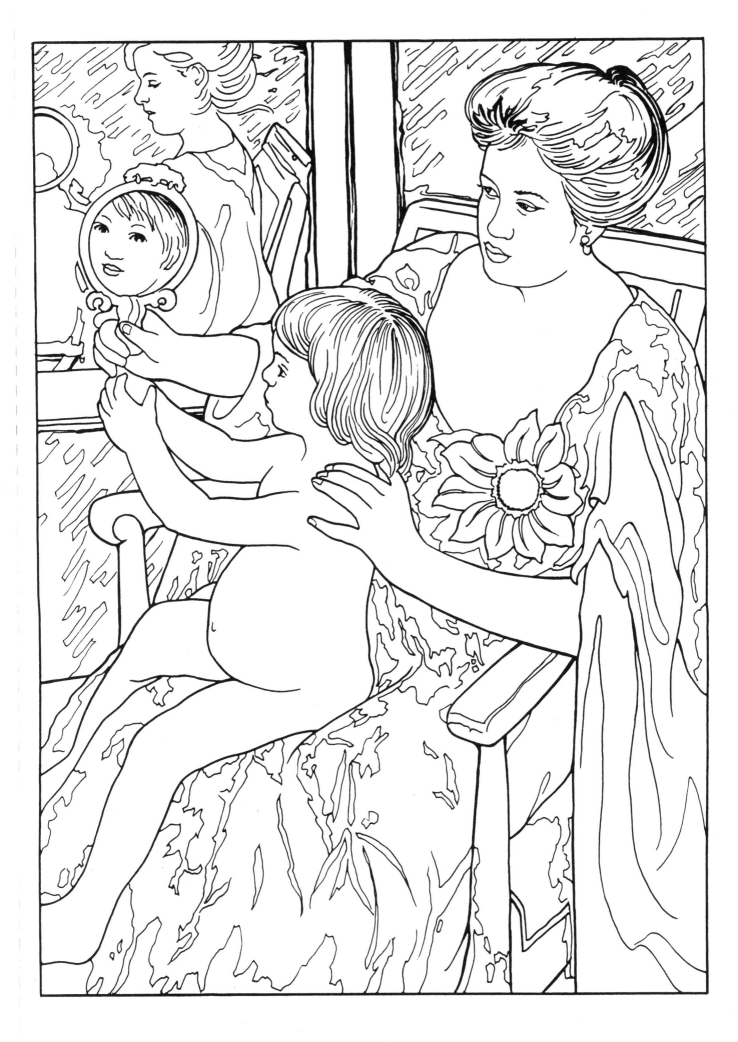

Plate 5
Mary Cassatt. *Mother and Child*, 1905.
Oil on canvas. 36¼ x 29 in.

Born in Pennsylvania, Cassatt was the only American female member of the Impressionists. She studied art at the Pennsylvania Academy of Art and then traveled to Europe, spending most of her life in Paris. Professionally, she was greatly influenced by her close friend, French Impressionist painter Edgar Degas. Cassatt painted family scenes of mothers and children, and achieved recognition for these tender representations. She was also very much influenced by Japanese woodcuts, and excelled in making woodcut prints. Her eyesight began to fail in 1900, and Cassatt stopped working by 1914. Like many of her paintings, this work depicts a mother and her child in a private moment of everyday life.

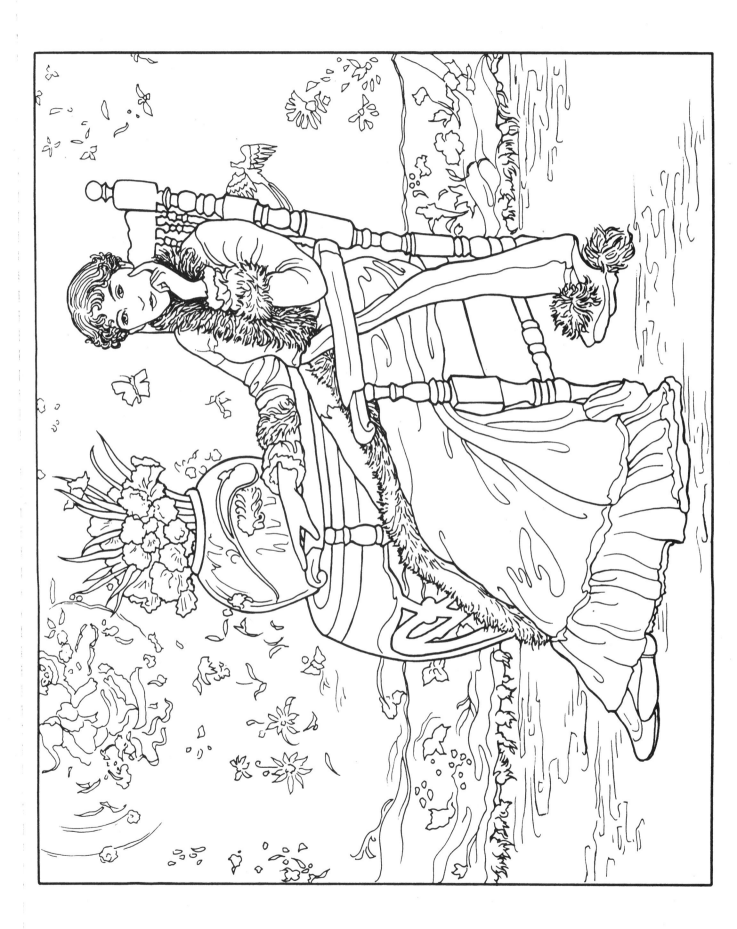

Plate 6
William Merritt Chase.
Portrait of Miss Dora Wheeler, 1883.
Oil on canvas. 62½ x 65¼ in.

Admired for his portraits, landscapes, and everyday scenes, Chase was bom in Indiana and studied in Munich as a young man. After his return to the U.S., he gained a fine reputation as a painter and a teacher. Chase was particularly influenced by James McNeill Whistler, and even adopted that artist's flat, decorative style for a time. An excellent example of his early work, this painting depicts Miss Dora Wheeler, a textile designer who studied painting under Chase in New York City.

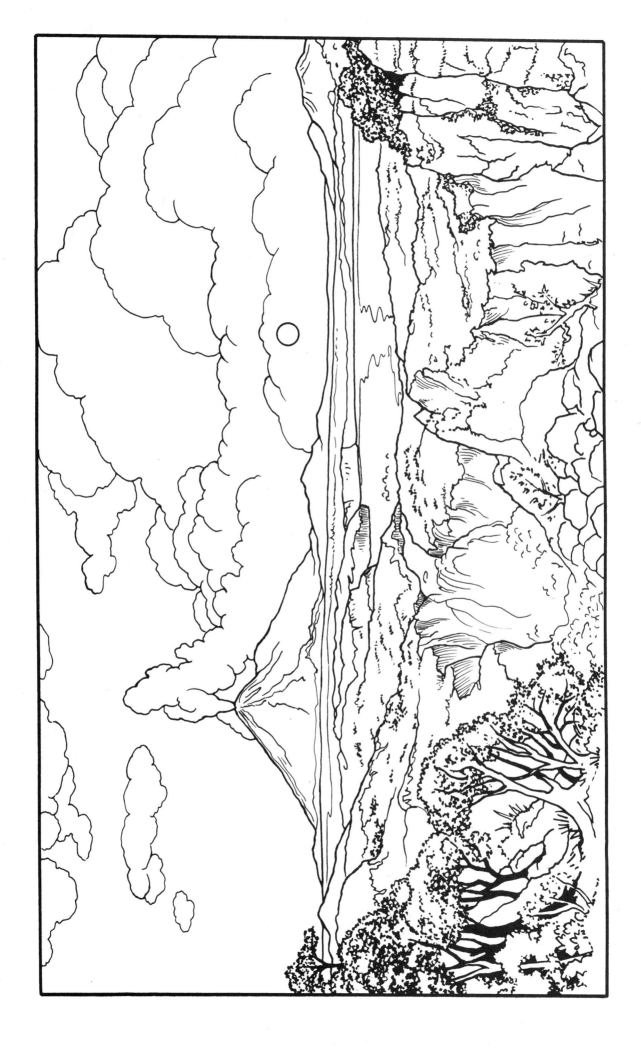

Plate 7
Frederic Church. *Cotopaxi*, 1862.
Oil on canvas. 48 x 85 in.

Born in Hartford, Connecticut, Frederic Edwin Church studied under the great landscape painter Thomas Cole, and made his mark as part of the Hudson River School of American Landscape Painters. Though most of his contemporaries in the Hudson River School worked on local subjects, Church's work is noted for its romantic portrayal of landscapes in America and beyond. In Cotopaxi, Church depicts a smoldering volcano in Ecuador, set against a tranquil scene of South American countryside life.

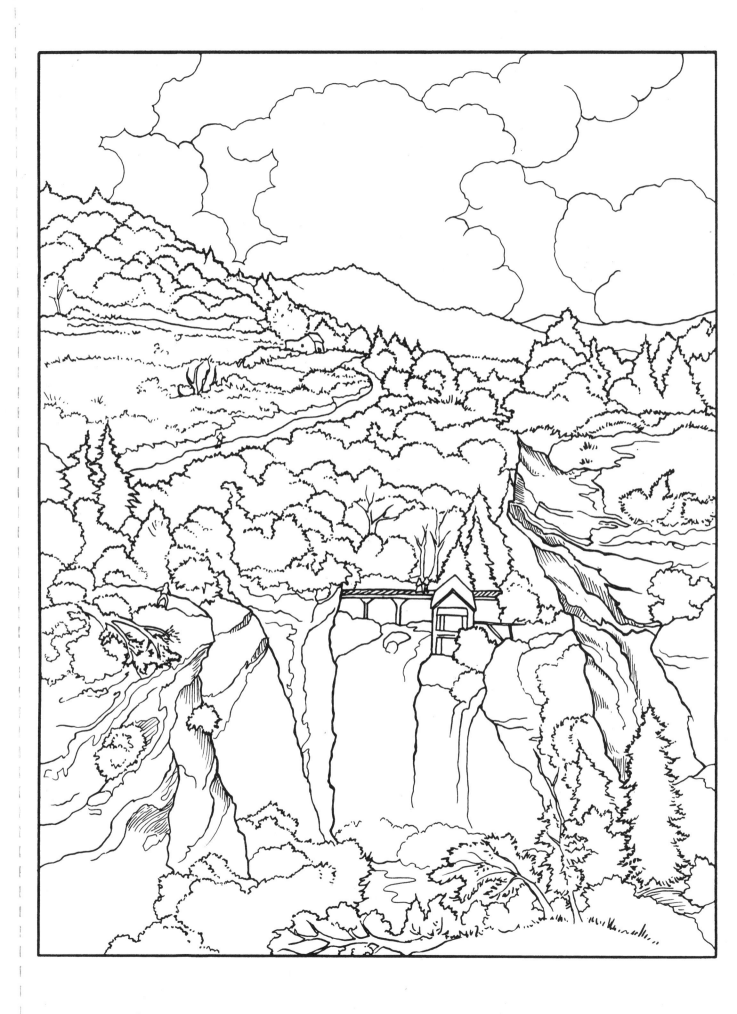

Founder of the much-lauded Hudson River School of American Landscape Painters, Thomas Cole's work is known for its detailed and romanticized depiction of the American wilderness. Though he was born and raised in Lancashire, England, he did not begin painting until after his family emigrated to Ohio when he was seventeen. This painting depicts a bridge and mountain landscape on the Genesee river in upstate New York.

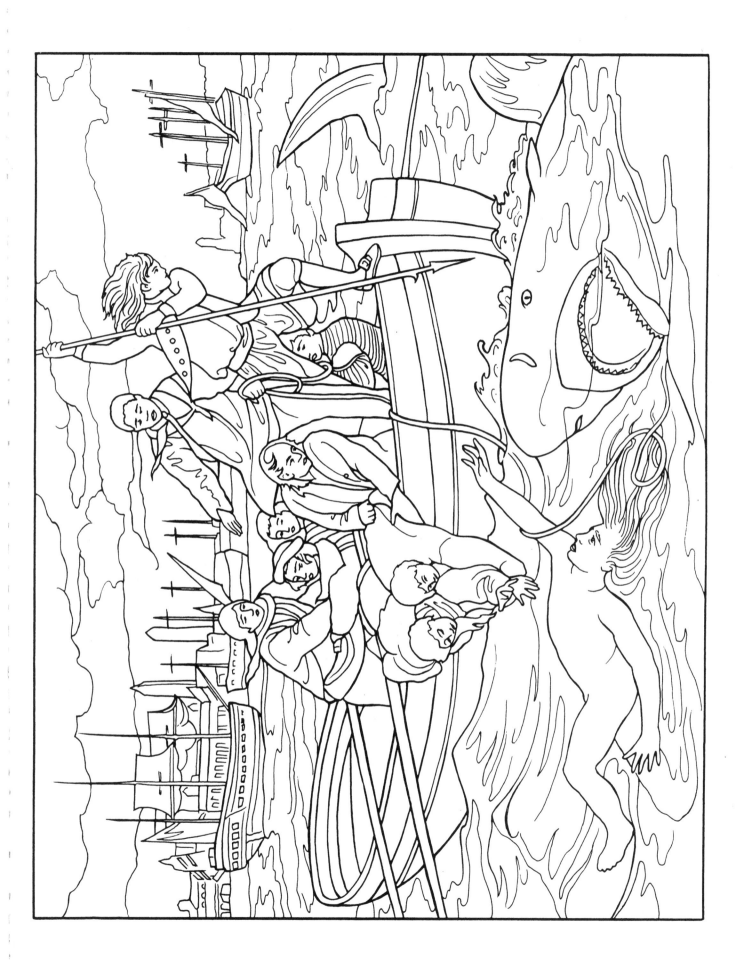

Plate 9
John Singleton Copley. *Watson and the Shark*, 1778.
Oil on canvas. 71¾ x 90½ in.

Known mostly for his portraits, John Singleton Copley was an active and sought-after painter in both colonial America and England. Copley began his career early, painting his first portrait at the age of fourteen and becoming an admired professional portrait painter before turning twenty. The subject of this painting is the rescue of future London Mayor Brook Watson from a shark attack in Havana, Cuba when he was a 14 year-old cabin boy.

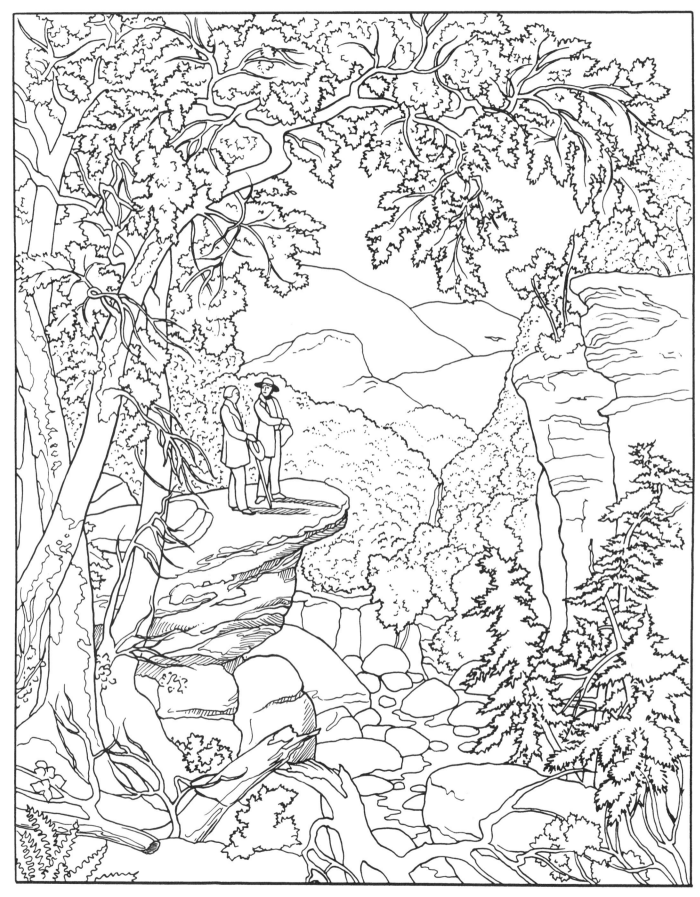

Plate 10
Asher B. Durand. *Kindred Spirits*, 1849.
Oil on canvas. 46 x 36⅛ in.

Asher B. Durand, an American painter, engraver, and illustrator, was one of the founders of Hudson River School, a style of landscape painting that showcased the beauty of nature. He was among the first American painters to work directly from nature out-of-doors. The artist's legacy includes hundreds of breathtaking compositions depicting mainly the Adirondacks, the Catskills, and the White Mountains of New Hampshire. This painting—Durand's best-known work—shows his two friends, landscape painter Thomas Cole and poet William Cullen Bryant, in an intricately detailed forest setting in the Catskill Mountains in New York.

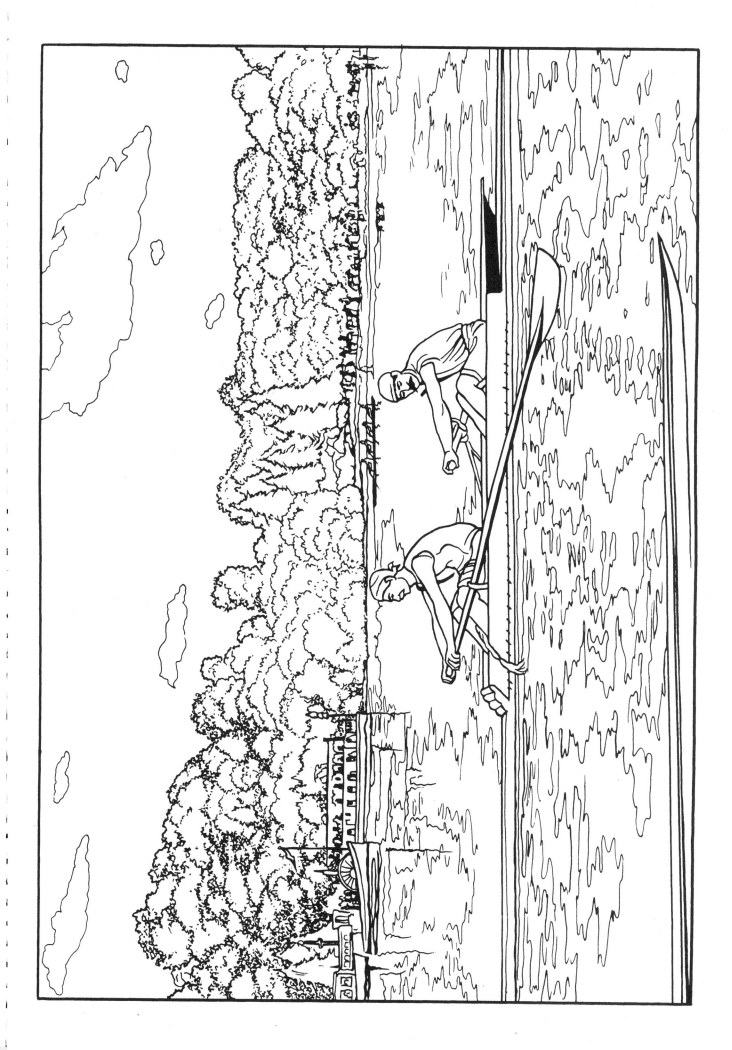

Plate 11
Thomas Eakins. *The Biglin Brothers Racing*, 1873.
Oil on canvas. 24 x 36 in.

Widely considered one of the most important artists in American history, Thomas Eakins was an American realist whose work centered on the lives and people of Philadelphia between 1870 and 1910. An amateur rower, Eakins painted dozens of scenes depicting different variations of the sport. This painting shows the Biglin Brothers of New York, national champions, rowing on the Schuylkill River during a trip to Philadelphia in the early 1870s.

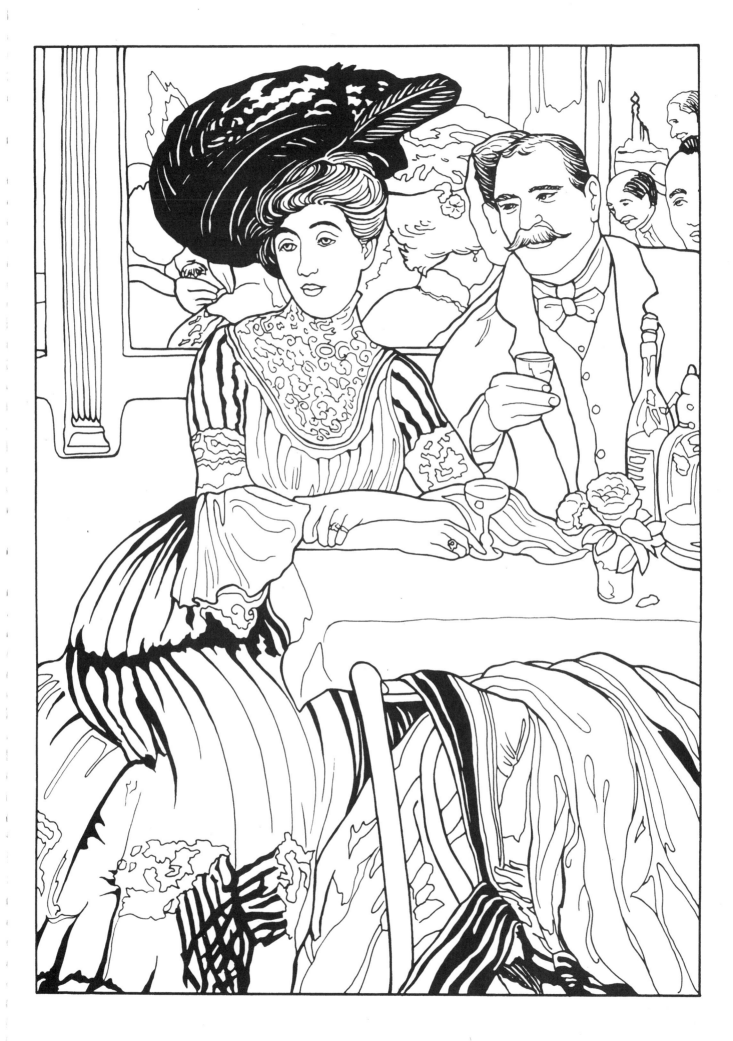

Plate 12
William Glackens. *Chez Mouquin*, 1905.
Oil on canvas. 48 x 39 in.

Born in Philadelphia, William Glackens studied at the Pennsylvania Academy of Fine Arts under the instruction of painter Robert Henri. Glackens was a member of the Ashcan school and was also one of "The Eight," a group of realist painters who exhibited their works together in 1908. Strongly influenced by the Impressionists, he painted subjects from everyday urban life as well as scenes of fashionable society. The subjects of this painting are Jeanne Lousie Mouquin and James B. Moore, who are depicted here in Jeanne Mouquin's restaurant, the Uptown Mouquin in New York City.

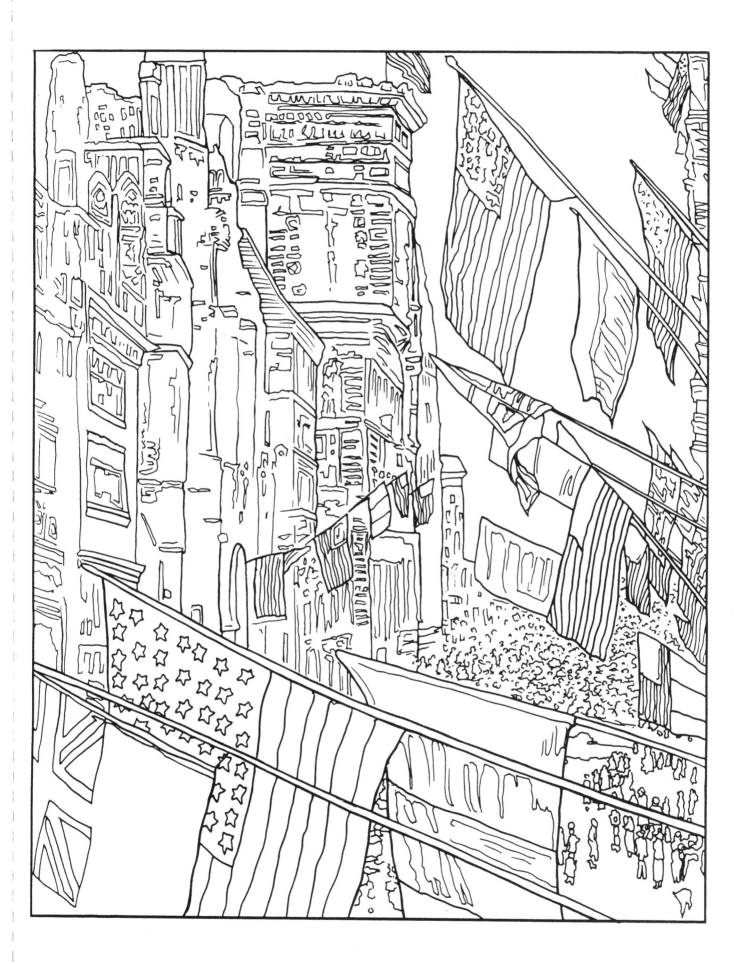

Plate 13
Childe Hassam. *Allies Day, May 1917*, 1917.
Oil on canvas. 36¾ x 30¼ in.

A notable figure in the American Impressionist movement, Childe Hassam was often referred to as the "American Monet." Along with fellow artists such as William Merritt Chase and John Twachtman, Hassam formed the group known as The Ten American Painters. Their annual exhibitions greatly encouraged the spread of Impressionism and helped carry the art style into the twentieth century. This piece portrays Fifth Avenue in New York City while it was lined with flags during World War I.

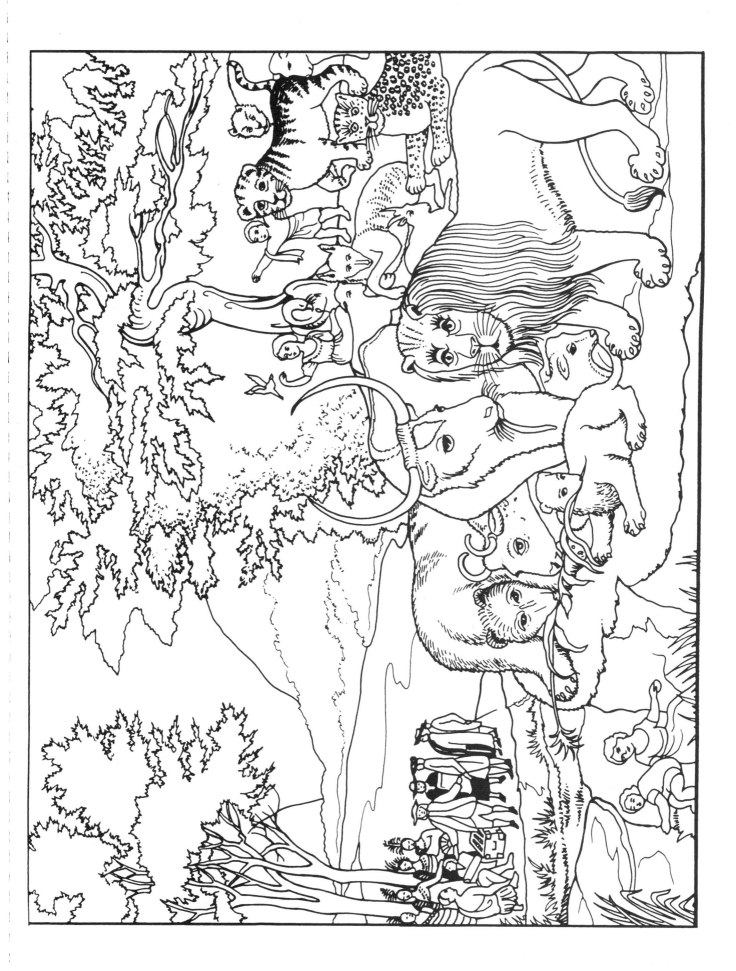

Plate 14
Edward Hicks. *The Peaceable Kingdom*, ca. 1837.
Oil on canvas. 29 x 36 in.

A Pennsylvania sign painter and Quaker preacher, self-taught folk artist Edward Hicks is thought to have painted between 60 and 100 different versions of Peaceable Kingdom. The Peaceable Kingdom paintings were Hicks' interpretations of the biblical passage from Isaiah 11, which states that all men and beasts live in harmony. In the background of this painting, William Penn is pictured with others making a treaty with the Leni-Lenape Indians.

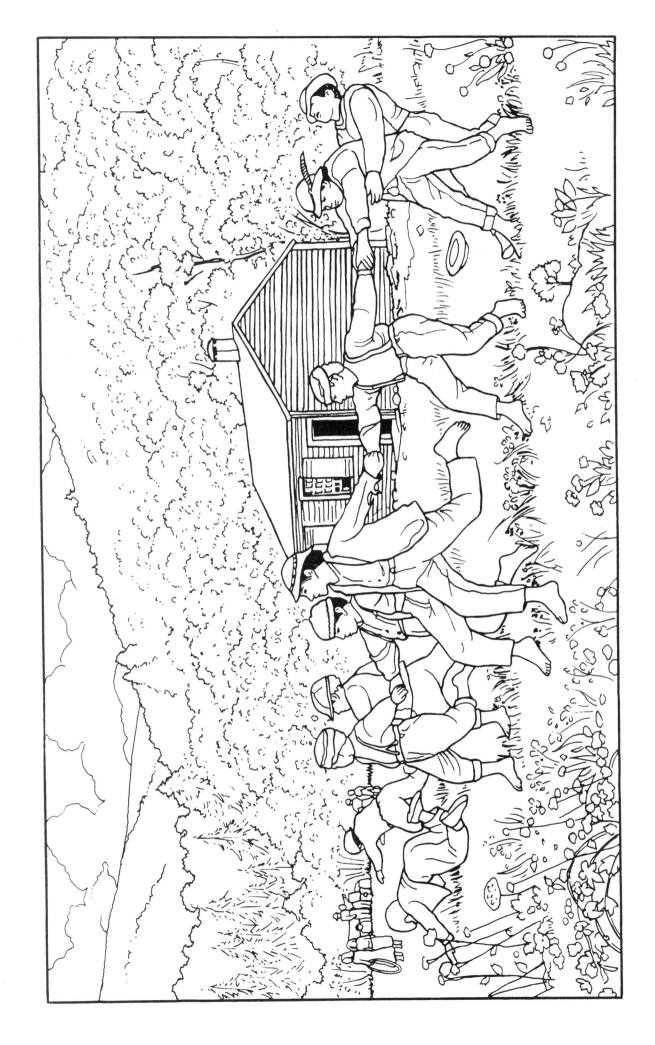

Winslow Homer. *Snap the Whip*, 1872.
Oil on canvas. 22¼ x 36½ in.

Winslow Homer was one of America's most prominent re-alist painters. His attention to detail and fascination with subjects from everyday life came from his early experiences as a magazine illustrator during the Civil War. The boys in this picture are playing Snap the Whip, a recess game also known as Crack the Whip. To play, children hold hands in a long line and then run fast. The first ones in line stop sud-denly, yanking the other kids sideways and causing the ones on the other end to break the chain and fall.

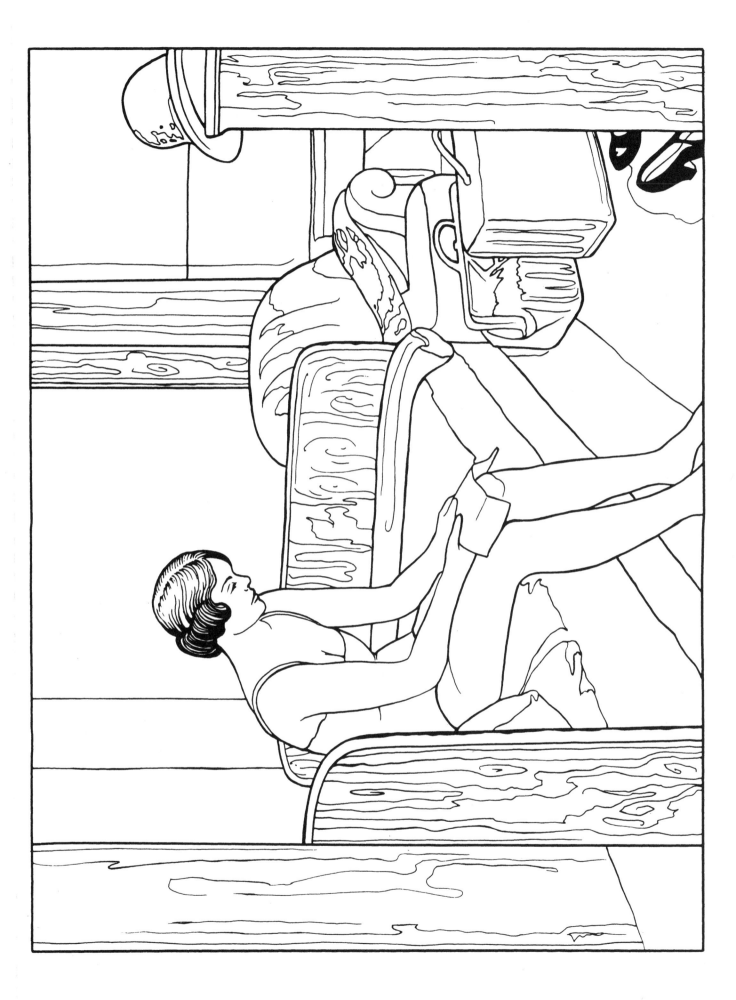

Plate 16
Edward Hopper. *Hotel Room*, **1931.**
Oil on canvas. 60 x 65 in.

Twentieth-century Realist painter Edward Hopper is best known for his paintings that seem to emphasize the loneliness and alienation found in our society. Born in Nyack, New York, Hopper studied commercial art before switching his efforts to line art. He studied with Robert Henri, a member of the Ashcan school of painters, who typically painted scenes of city life. Hopper traveled to Europe three times between 1906 and 1910, but he remained unaffected by the avant-garde art movements burgeoning there. Taken as a whole, Hopper's work poignantly evokes the essence of American urban life. Like many of Hopper's figure paintings, *Hotel Room* depicts a woman alone in a room, and uses the painting's composition to emphasize her solitude.

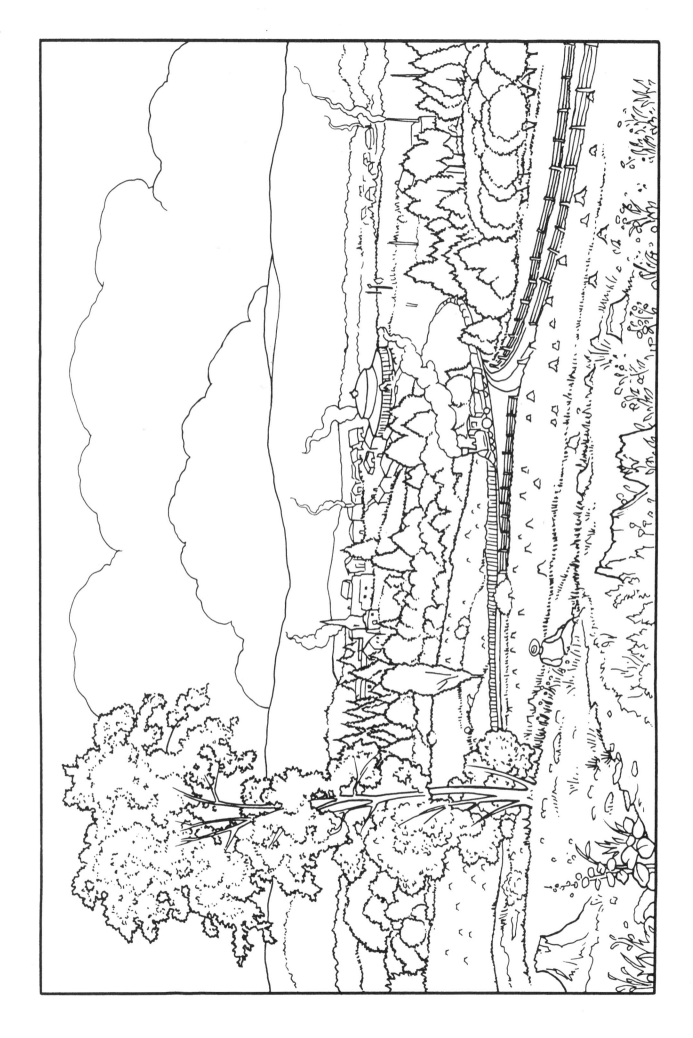

Plate 17
George Inness. *The Lackawanna Valley*, 1855.
Oil on canvas. 34 x 50 in.

Often referred to as the "father of American landscape painting," the art of George Inness influenced generations of American painters. Best known for the sweeping landscapes he produced later in his career, his work was greatly influenced by the ideas of Swedish philosopher Emanuel Swedenborg. *The Lackawanna Valley* was created as a commission for the Delaware, Lackawanna, and Western Railroad. It depicts the railroad's first roundhouse in Scranton, Pennsylvania.

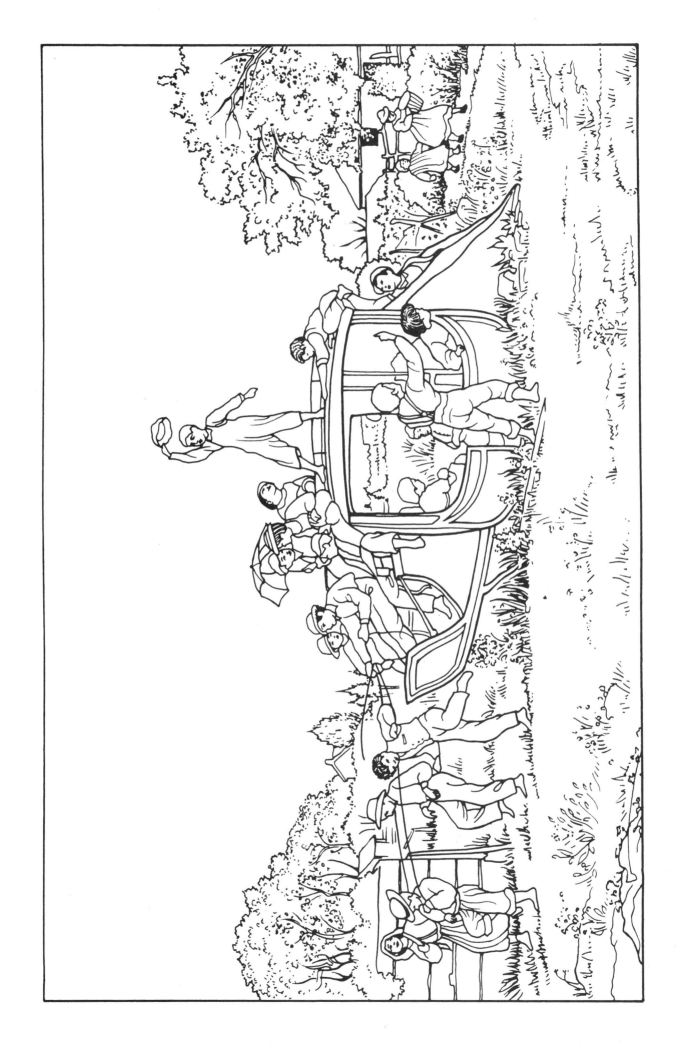

Plate 18
Jonathan Eastman Johnson.
The Old Stagecoach, 1871.
Oil on canvas. 36¼ x 60⅛ in.

Jonathan Eastman Johnson was an American painter best known for his depictions of everyday life in the nineteenth century, and his portraits of prominent Americans of the time. Known during his life as "The American Rembrandt," Johnson's portrait subjects included Abraham Lincoln, Nathaniel Hawthorne, Ralph Waldo Emerson, and Henry Wadsworth Longfellow. Although the setting of this painting came from a drawing Eastman made of an abandoned stagecoach in the Catskills, the children it depicts were staged by the artist on a platform in Nantucket.

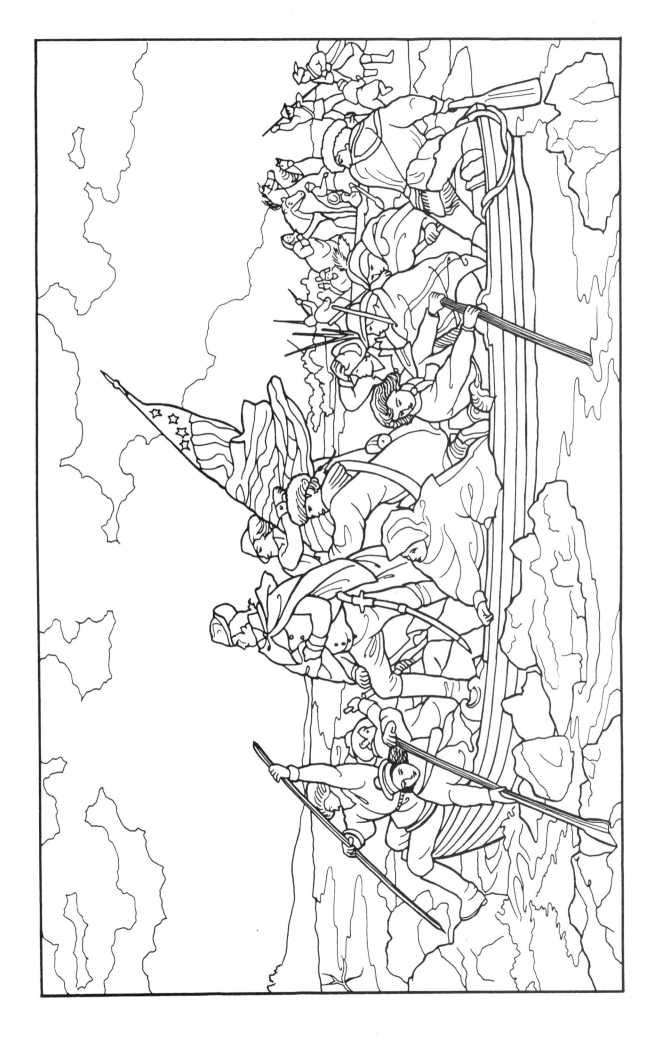

Plate 19
Emanuel Leutze.
Washington Crossing the Delaware, 1851.
Oil on canvas. 149 in. x 255 in.

Among the most popular historical painters in mid-nine-teenth-century America, Emanuel Leutze was born in Germany, but grew up in Philadelphia. His most famous work was *Washington Crossing the Delaware*, the first ver-sion of which was destroyed in a bombing raid during World War II. This version of the work, enormously popu-lar in both America and Germany, was placed on exhibi-tion in New York in 1851. Many studies for the painting still exist, as well as the engraving that was published in 1853 and circulated widely.

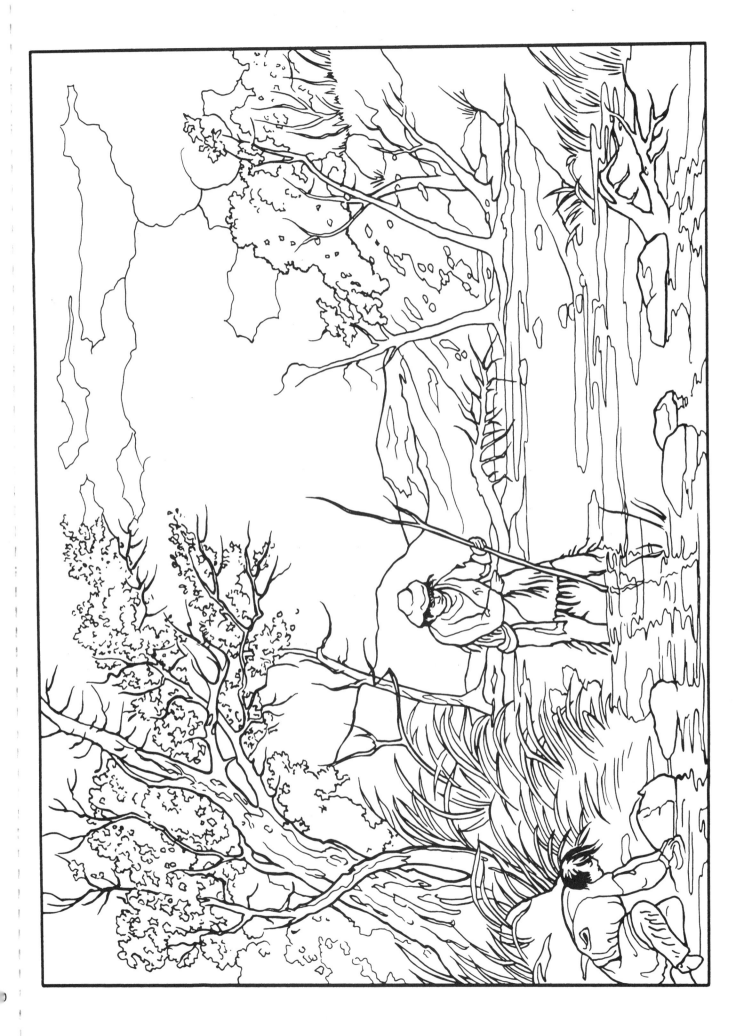

Plate 20
Alfred Miller. *Setting Traps for Beaver*, 1837.
Watercolor. 7⅞ in. x 10¼ in.

Although he was born in Baltimore, Maryland, and spent much of his career working in New Orleans, Alfred Jacob Miller is primarily remembered for his paintings of the American West, and of the Rocky Mountains in particular. Having studied with "The Romantics" in Paris, his paintings often reflect their romantic sensibilities in their portrayal of the American landscape. This painting depicts a pair of trappers setting five-pound traps in a river where they believe beavers are present.

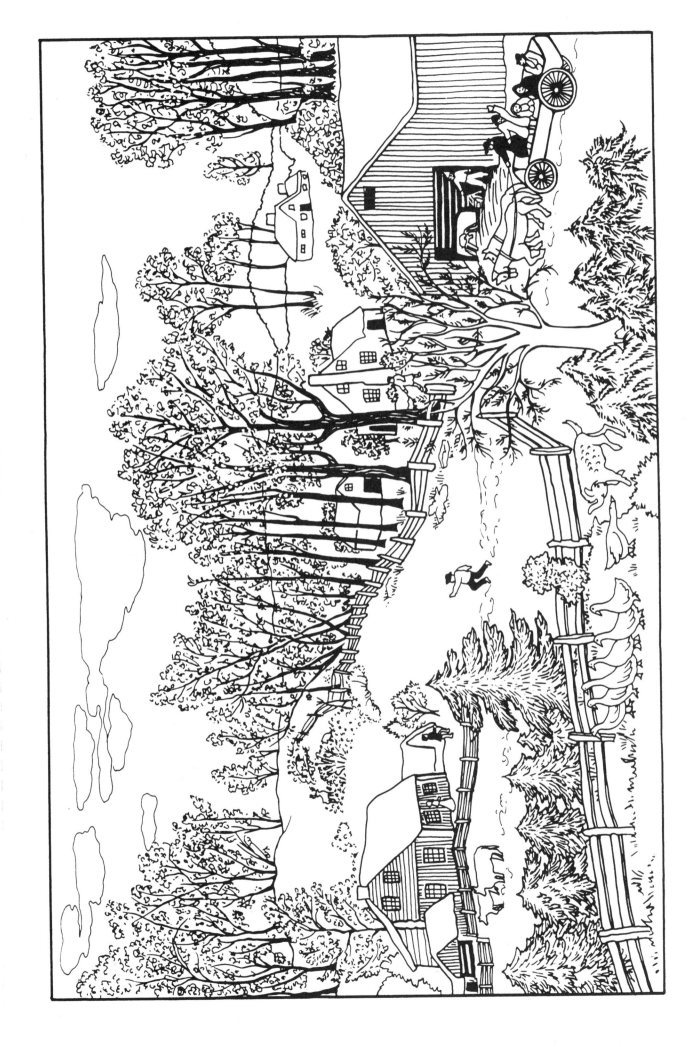

Plate 21
Grandma Moses. *Early Springtime on the Farm*, **1945.**
Oil on canvas. 16 x 25¾ in.

One of the greatest folk painters of the twentieth century, Grandma Moses first began to paint at the age of seventy-eight. Born on a farm in Greenwich, New York, just before the Civil War, she primarily painted landscape scenes of country life. In 1939, her paintings were exhibited at the Museum of Modern Art in New York City. She produced 2,000 detailed paintings in all, some of which were used on Christmas cards and reproduced in prints. Grandma Moses died at the age of one hundred and one. The title of this painting is intended to be humorous, as it claims the scene to be "Early Springtime" in New England, while there is still a good deal of snow covering the landscape.

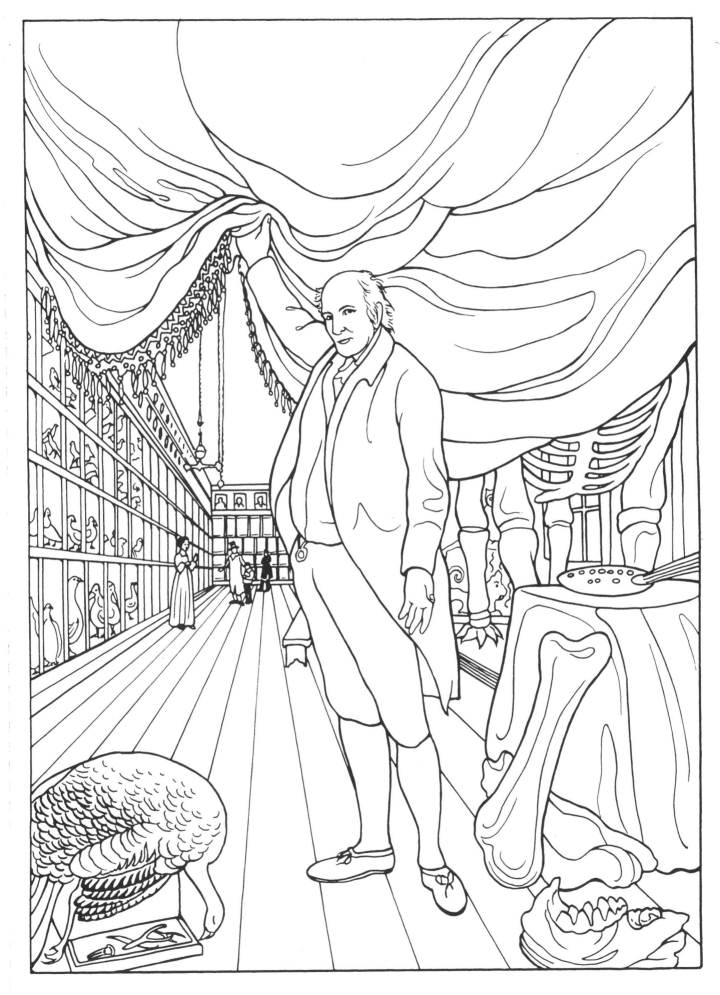

Plate 22
Charles Willson Peale. *The Artist in His Museum*, **1822.**
Oil on canvas. 103¾ x 79⅞ in.

Founder of Peale's American Museum in Philadelphia, Charles Willson Peale is best known for his portraits of leading figures from the American Revolution, which include Benjamin Franklin, John Hancock, Thomas Jefferson, George Washington, Alexander Hamilton, and many others. *The Artist in His Museum* is a nearly life-sized self-portrait, in which Peale depicts himself posing in the museum he founded.

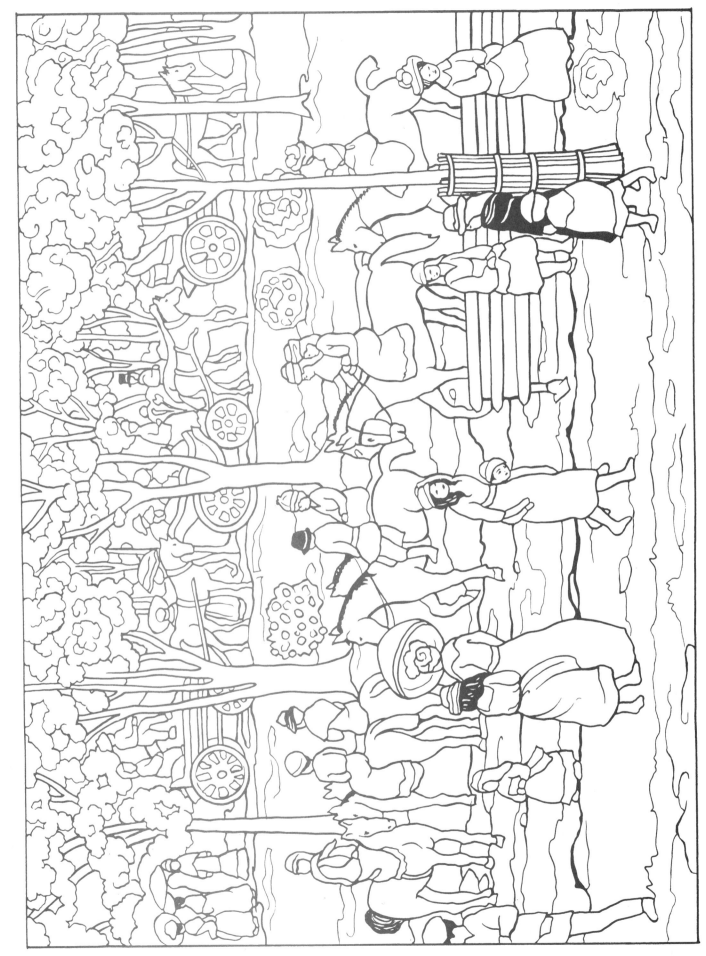

Plate 23
Maurice Prendergast. *Central Park*, c. 1908–10.
Oil on canvas. 20¾ x 27 in.

Born in St. John's, Newfoundland, Canada, Maurice Prend-
ergast grew up in Boston, and returned there as an adult
to set up an art studio. In the early 1890s, he traveled
abroad to study art in both Paris and Italy and was par-
ticularly inspired by Post-Impressionism. He developed his
own signature style of blocks of color and dark outlines,
creating mosaic or stained glass-like effects in his paint-
ings and watercolors. Central Park is a typical example of
the artist's many scenes of people gathered in New York or
by the seaside.

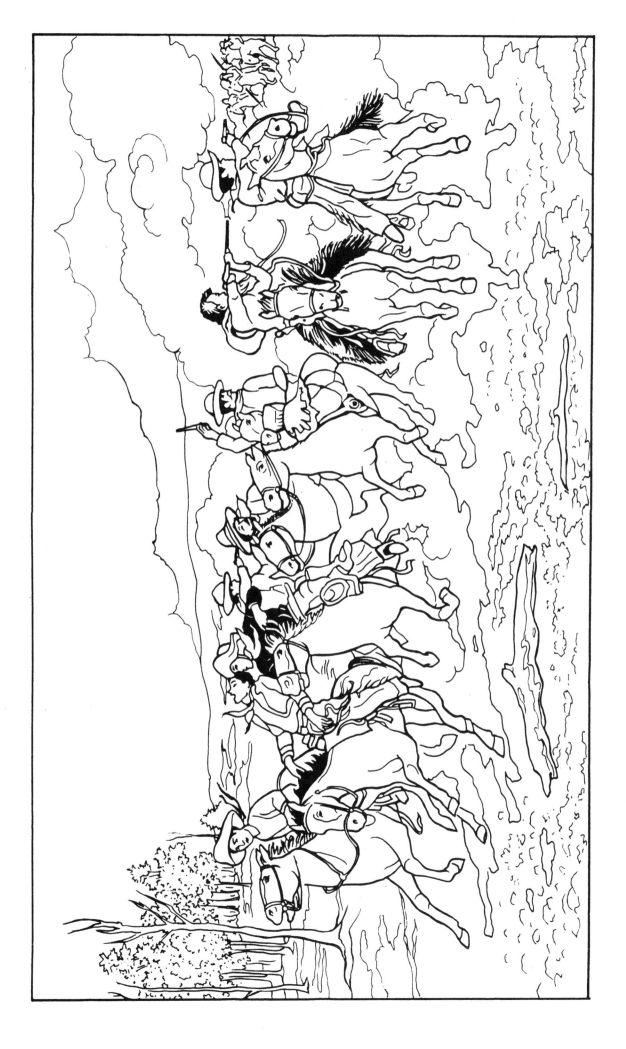

Plate 24
Frederic Remington. *A Dash for the Timber*, **1889.**
Oil on canvas. 48½ x 84⅛ in.

Famous for his depictions of the nineteenth-century American West, Frederic Remington's favorite subjects included action scenes of Native Americans, cowboys, and the U.S. cavalry. Remington left college in order to travel across the U.S., working as a cowboy and prospector, while filling a journal with observations and that he would later use in his paintings. This painting, which depicts a group of cowboys in a gunfight with Native Americans, launched Remington's career as a major artist when it was exhibited at the National Academy in 1889.

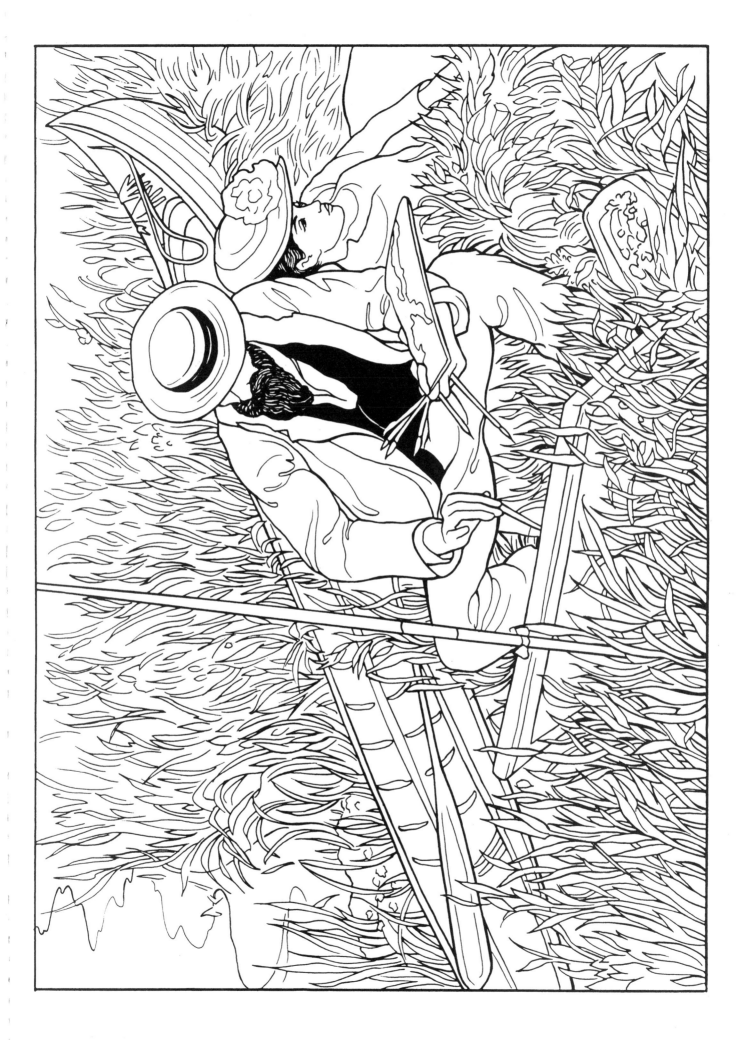

Plate 25
John Singer Sargent.
Paul Helleu Sketching with His Wife, **1889.**
Oil on canvas. 26⅛ x 32⅛ in.

Portrait painter John Singer Sargent was born in Florence, Italy, to American parents. As a child, Sargent traveled with his parents around Europe, and gained experiences that would contribute greatly to his self-assurance with all kinds of people and places. Exquisite portrayals of affluent figures of the day and their families made Sargent a much sought-after artist, and many patrons clamored for his refined, flattering style. Sargent went through a brief Impressionist phase, inspired by the work of Claude Monet at Giverny. In this painting, Sargent employs the French *plein air* technique, depicting Paul Helleu and his wife in natural light when they visited him in the countryside.

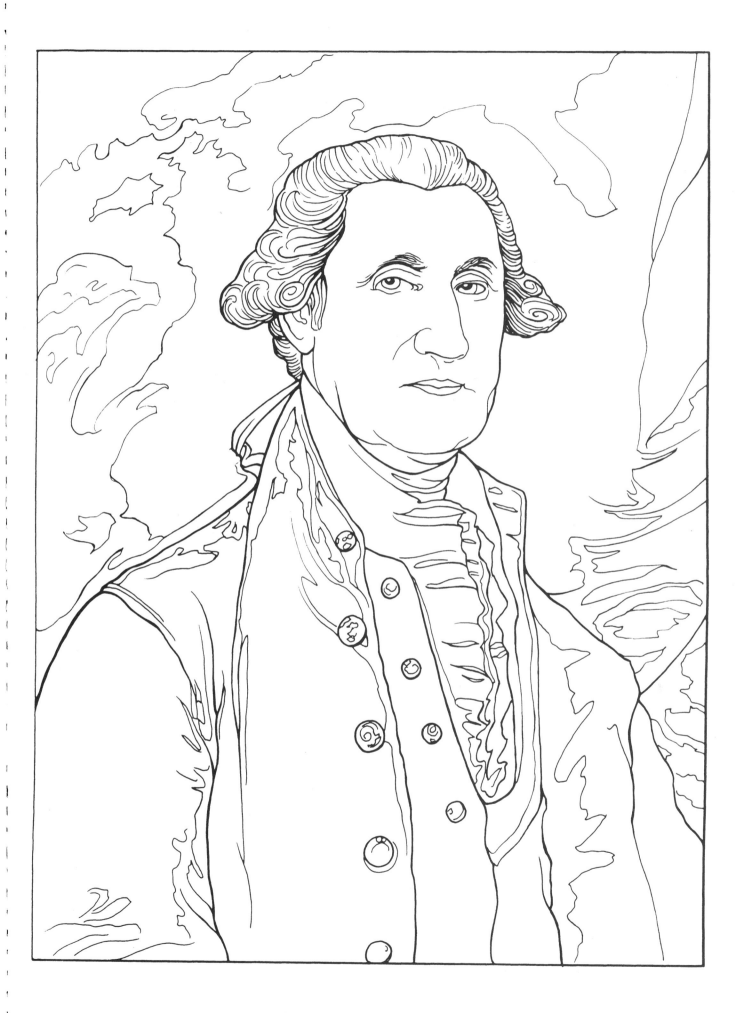

Plate 26
Gilbert Stuart. *George Washington*, 1795.
Oil on canvas. 29¼ x 24 in.

Known as one of America's greatest portrait painters, Gilbert Stuart created over 1,000 portraits throughout the course of his career, including portraits of the first six Presidents of the United States. His most famous work is an unfinished portrait of George Washington, which appeared on the one-dollar bill for over a century. This painting of George Washington is one of eighteen similar portraits, with the first most likely painted from life and the rest created as copies of the original.

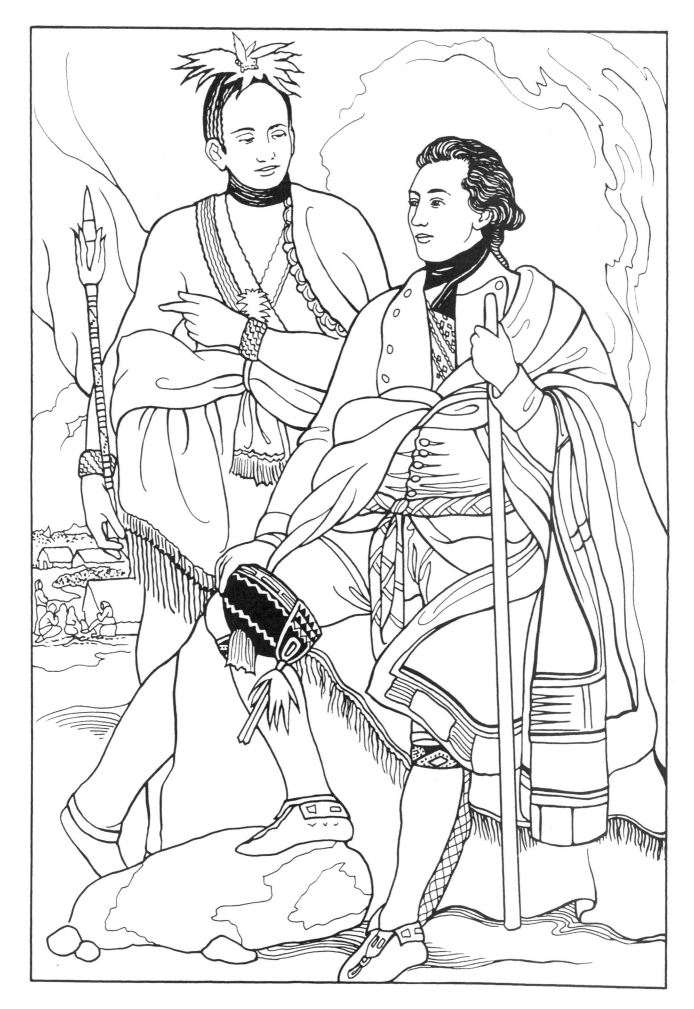

Plate 27
Benjamin West. *Colonel Guy Johnson*, **1775.**
Oil on canvas. 79¾ x 54½ in.

Known mostly for his paintings of historical scenes around the time of the American Revolution, Benjamin West was one of the first American artists to receive an international reputation. Though he was born in rural Pennsylvania, West would spend most of his life living in England, where he eventually founded the Royal Academy. The subjects of this portrait are military officer and diplomat Guy Johnson and Mohawk chief Karanghyontye.

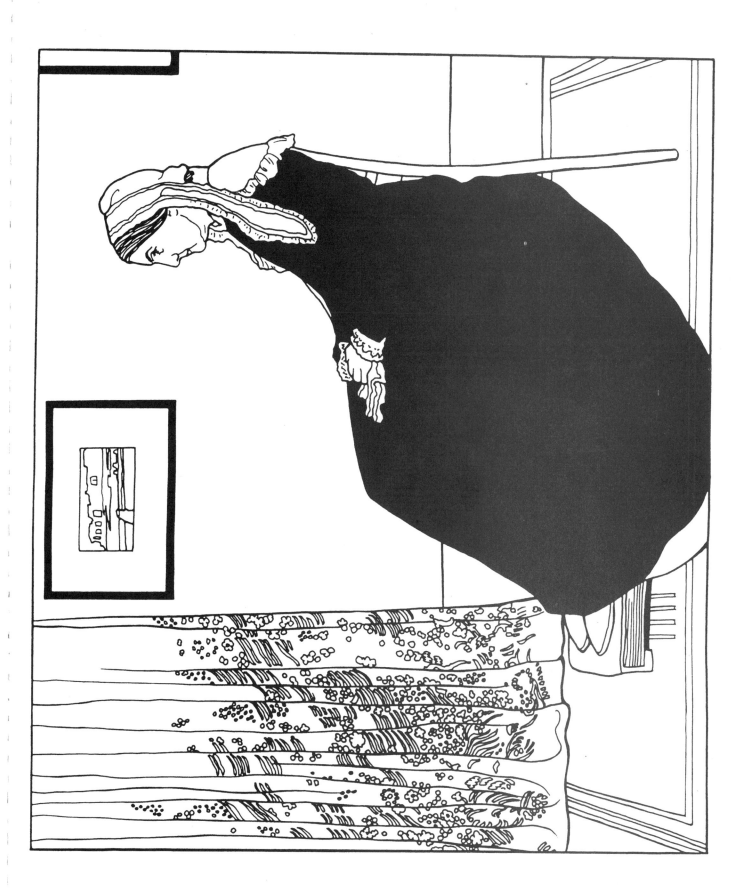

Plate 28
James McNeill Whistler.
Portrait of the Artist's Mother, **1871.**
Oil on canvas. 56¾ x 64 in.

American painter and etcher James Abbott McNeill Whistler was born in Lowell, Massachusetts. He spent his childhood in Russia, where his father worked as a civil engineer. In 1855, Whistler traveled to Paris to study art and remained in Europe for the rest of his life. During the 1860s, Whistler developed a fascination with Japanese art, and began to incorporate Oriental fans and blossoms into his paintings. A propagandist of the "art for art's sake" philosophy, Whistler believed that painting should exist for its own sake without conveying literary or moral ideas. In his later years, Whistler, who worked in watercolors, pastels, and executed more than fifty etchings, came to be regarded as a major artist of refreshing originality as well as a champion of modern art. Arguably Whistler's most famous painting, *Portrait of the Artist's Mother* would become an icon in American art, receiving its own postage stamp in 1934 that bore the slogan, "In Memory and in Honor of the Mothers of America."

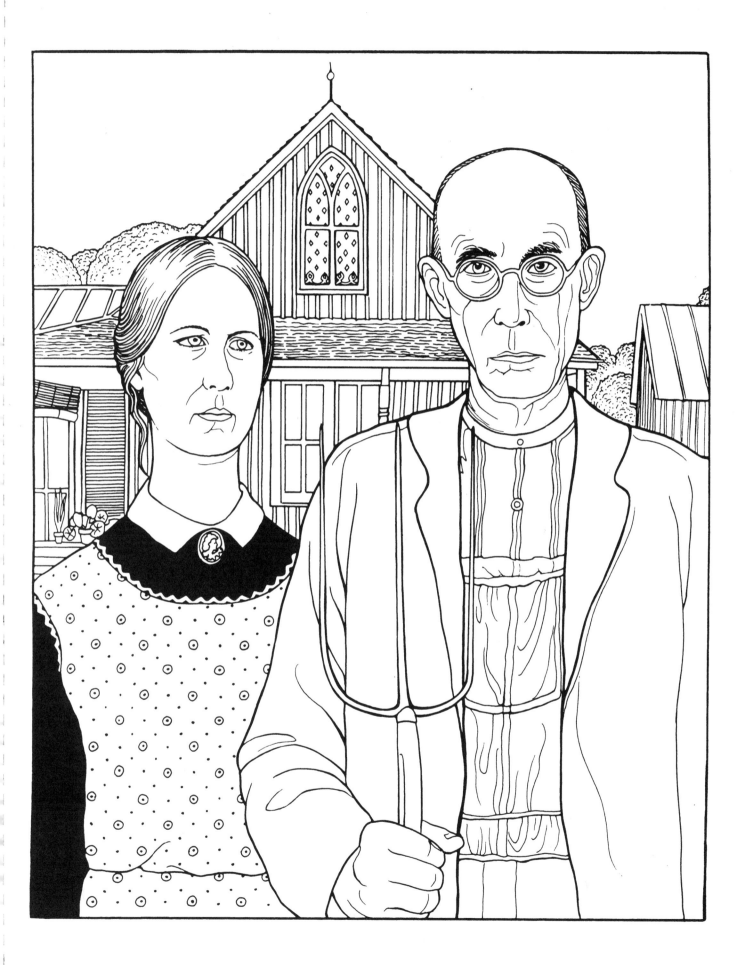

Plate 29
Grant Wood. *American Gothic*, 1930.
Oil on beaverboard, 29 x 24½ in.

Born in Iowa, Grant Wood asked his dentist and his sister to pose as a farmer and his unmarried daughter for what has become one of the most famous (and most parodied) paintings in the history of American art, *American Gothic*. Although Wood was accused of ridiculing the narrow-mindedness of rural life, he denied the allegation, insisting that his painting was not a caricature of rural America, but a celebration of the values of the Midwest. The painting's title is derived from the Gothic Revival style of the cottage in the background.

Plate 30
N. C. Wyeth. *Nothing Would Escape*, 1911.
Oil on canvas. 46½ x 37½ in.

Considered one of America's greatest illustrators, N.C. Wyeth was also a respected and accomplished painter. Born in Needham, Massachusetts in 1882, Wyeth's career took off from an early age, with his first commissioned illustration coming from the *Saturday Evening Post* at a mere 21 years old. Throughout the course of his life he would illustrate 112 books and create over 3000 paintings. This work is typical of Wyeth in its dramatic depiction of Native Americans. It first appeared in the November 1911 issue of *Harper's Monthly Magazine*.